the galleri

contemporary fine art galleries in london

THE AGENCY. CONTEMPORARY LTD

ANDREW MUMMERY GALLERY

ANTHONY REYNOLDS GALLERY

ANTHONY WILKINSON GALLERY

THE APPROACH

ASPREY JACQUES

CORVI-MORA

EMILY TSINGOU GALLERY

ENTWISTLE

ESSOR GALLERY

FA PROJECTS

FRITH STREET GALLERY

GAGOSIAN GALLERY

GREENGRASSI

HALES GALLERY

LAURENT DELAYE GALLERY

LISSON GALLERY

MAGNANI

MAUREEN PALEY INTERIM ART

MICHAEL HUE-WILLIAMS FINE ART

MOBILE HOME

MODERN ART

MW PROJECTS

NYLON

ONE IN THE OTHER

RHODES+MANN

SADIE COLES HQ

STEPHEN FRIEDMAN GALLERY

TIMOTHY TAYLOR GALLERY

VICTORIA MIRO GALLERY

VILMA GOLD

VTO

WHITE CUBE

CONTENTS

map: north & east

map: south

list of artists

introduction

what is it that makes good galleries indispensable to the process
of evaluating, sifting and disseminating the virtually endless
production of art around the world?

many people think that galleries exist merely to make profit at
the expense of artists. sometimes this may be true. but effective
galleries are so much more than that. like publishers, galleries
represent artists who they believe in, providing them with a critical
context in which their work can be shown to the public. far more
than museums and even the most innovative public spaces, gallerists
devote a great deal of personal energy and considerable financial
support to this, making it possible for artists to take risks and to
present their work in the way they wish.

of course, certain critics and curators as well as artists themselves
have been responsible for bringing new art to the fore. but the
fact remains that over the last one hundred and fifty years, great
galleries, run by remarkably committed individuals, have backed
many of the most significant artists and movements in art. the
late decades of the nineteenth century saw the advent of the
impressionists and post-impressionists, who were supported by paul
durand-ruel and ambroise vollard while the public laughed at what
they saw as their 'unfinished' pictures. their work was also shown in
germany by paul cassirer and in glasgow by alex reid. henri
kahnweiler confounded his contemporaries by championing cubism
and picasso's early work. in the united states from the 1930s to the
1950s gallerists like julien levy, pierre matisse, sidney janis and betty
parsons played an important role in promoting surrealism and the

abstract expressionist work of artists such as pollock and rothko.
the great pop artists – johns, rauschenberg, lichtenstein and many
more – were supported at a pivotal time in their development
by richard bellany and subsequently by leo castelli and ileana
sonnabend. in england, robert fraser and john kasmin nurtured the
british pop scene and played a significant role in bringing american
art to london. helen lessore was a vital force in establishing artists
such as bacon, auerbach, kossoff and andrews, and the worldwide
success of german art in the 1970s and 1980s owed much to the
energy of konrad fischer and michael werner, among others.

great galleries recognise and commit to work that is ahead of its
time. they devise strategies with artists that bring challenging new
work to the attention of the public, of collectors and of museums.
this working relationship often results in gallerists and their artists
becoming lifelong friends.

over the last decade the number of galleries in london running
ambitious contemporary programmes has risen from under ten
to well over fifty. this book showcases thirty-three, all of them
sustaining serious, international, contemporary programmes of
individual character that are open completely free to the general
public. bringing these galleries together in this way will introduce
a larger public to the pleasures of regular visits to the galleries
of london.

norman rosenthal and max wigram

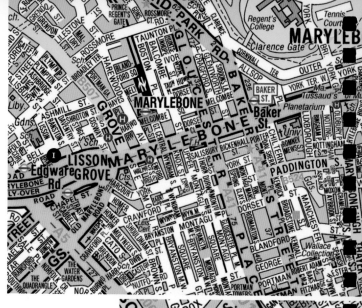

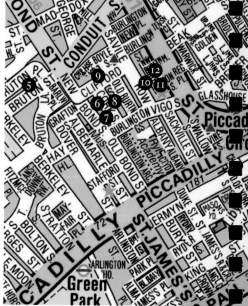

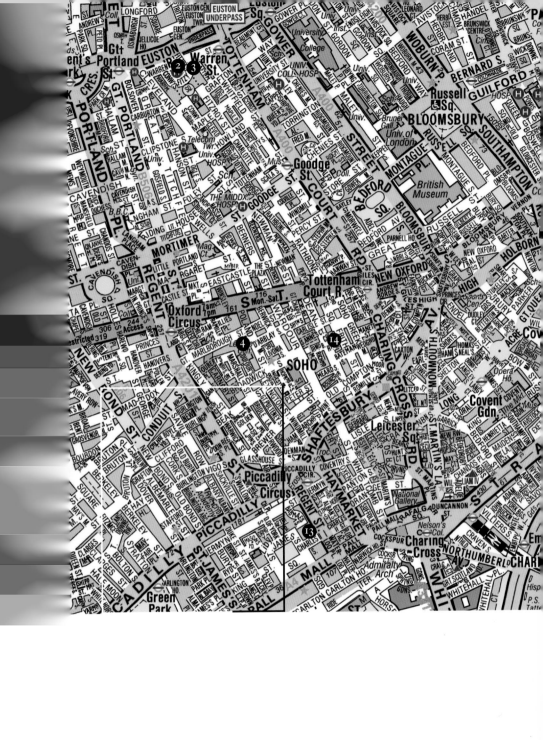

bus n° 9 10 14 19
line *bakerloo*
tube marylebone edgware road

contact@lisson.co.uk
www.lisson.co.uk
020 7724 2739
020 7724 7124

67 LISSON STREET NW1 5DA

LISSON GALLERY

open

contact nicholas logsdail, jill silverman van cœnegrachts

artists edward allington ◦ francis alÿs ◦ carl andre ◦ art & language ◦ john baldessari ◦ pierre bismuth ◦ christine borland ◦ roddy buchanan ◦ james casebere ◦ tony cragg ◦ grenville davey ◦ richard deacon ◦ lili dujourie ◦ ceal floyer ◦ douglas gordon ◦ dan graham ◦ rodney graham ◦ shirazeh houshiary ◦ peter joseph ◦ donald judd ◦ anish kapoor ◦ on kawara ◦ igor & svetlana kopystiansky ◦ john latham ◦ sol lewitt ◦ robert mangold ◦ jason martin ◦ john mccracken ◦ jonathan monk ◦ juan muñoz ◦ john murphy ◦ avis newman ◦ julian opie ◦ tony oursler ◦ giulio paolini ◦ simon patterson ◦ juliao sármento ◦ santiago sierra ◦ jemima stehli ◦ lee ufan ◦ jan vercruysse ◦ marijke van warmerdam ◦ richard wentworth ◦ jane & louise wilson ◦ sharon ya'ari

established in 1967 by nicholas logsdail, the lisson gallery pioneered in europe the work of such conceptual and minimal artists as carl andre, art & language, dan graham, on kawara, donald judd, richard long, yoko ono and robert ryman. for more than three decades the lisson gallery has been at the forefront of developments in contemporary art, introducing young artists to a wider audience as well as providing continuing support to those whose reputation is already established worldwide. the lisson gallery currently represents more than forty artists in three generations – including twelve turner prize winners and nominees – from minimal artists such as sol lewitt and robert mangold, to the 'new object' sculptors anish kapoor, richard deacon and tony cragg, and the younger british artists working with photography and film such as douglas gordon, christine borland, francis alÿs and jane & louise wilson. designed by tony fretton in 1991, the lisson gallery is the only purpose-built commercial exhibition space in london and is still visited by architecture students from all over the world. our new space at 29 bell street will be inaugurated with a show by santiago sierra on 10 september 2002.

image courtesy the artist and the lisson gallery, london

[1] *julian opie, 'sculpture films paintings', the lisson gallery, february 2001 installation view*

bus n° *10 18 24 27 29 30 73 88 134*

line *northern victoria circle metropolitan hammersmith&city*

tube *warren street great portland street*

info@greengrassi.com

www.greengrassi.com

020 7387 8747

020 7388 3555

39C FITZROY STREET W1T 6DY

GREENGRASSI

contact

cornelia grassi open

artists tomma abts ∘ stefano arienti ∘ matthew arnatt ∘ jennifer bornstein ∘
neil chapman & steven claydon ∘ steve doughton ∘ vincent fecteau ∘ samuel fosso ∘
giuseppe gabellone ∘ joanne greenbaum ∘ mary heilmann ∘ sean landers ∘ simon ling ∘
margherita manzelli ∘ david musgrave ∘ kristen oppenheim ∘ alessandro pessoli ∘ lari pittman ∘
charles ray ∘ karin ruggaber ∘ allen ruppersberg ∘ anne ryan ∘ cindy sherman ∘ frances stark ∘
jennifer steinkamp ∘ pae white ∘ lisa yuskavage

greengrassi opened in november 1997 with an exhibition of self-portraits from the early 1970s by the photographer samuel fosso. since then, the programme has included artists from both europe and the US working in sculpture, painting, photography, film and video.

schedule of exhibitions at greengrassi in the last two years:

26.09.00−04.11.00 vincent fecteau

15.11.00−20.01.01 cindy sherman, 'early work 1976–2000'

25.02.01−03.03.01 matthew arnatt, 'a touch of frost'

10.03.01−04.04.01 'smallish', curated by dennis cooper

06.04.01−12.05.01 joanne greenbaum & mary heilmann

23.05.01−23.06.01 anne ryan, 'red river yellow sky'

13.09.01−20.10.01 david musgrave

02.11.01−20.12.01 simon ling

19.12.02−02.03.02 pae white, 'the actual tigers'

08.03.02−13.04.02 frances stark, 'stark: self-portraiture'

20.04.02−25.05.02 tomma abts

01.06.02−27.07.02 alessandro pessoli, 'caligola and 15−18'

all images courtesy greengrassi, london

¹ *giuseppe gabellone, untitled, 2002 chromogenic development print, 210x150cm*

² *tomma abts, tedo, 2002 oil and acrylic on canvas, 48x38cm*

³ *david musgrave, form (head n°2), 2001 epoxy putty and paint, 28x42x26cm*

⁴ *simon ling, we'll always have eggs, 2001 oil on canvas, 122x91.5cm*

⁵ *allen ruppersberg, the sky above, the mud below (progress/adventure), 1988*
 collage on board, 92x73cm

1

2

3

4

5

bus nº *10 24 27 29 88*

line *victoria northern hammersmith&city circle metropolitan*

tube *warren street great portland street*

tcm@corvi-mora.com

www.corvi-mora.com

020 7383 2419

020 7383 2429

3

contact

22 WARREN STREET WIT 5LU

CORVI–MORA

open

tommaso corvi-mora

artists brian calvin ∘ pierpaolo campanini ∘ andy collins ∘ rachel feinstein ∘ liam gillick ∘ richard hawkins ∘ roger hiorns ∘ jim isermann ∘ aisha khalid ∘ eva marisaldi ∘ jason meadows ∘ monique prieto ∘ imran qureshi ∘ andrea salvino ∘ glenn sorensen ∘ tomoaki suzuki

I

tommaso corvi-mora founded corvi-mora in 2000, after having co-directed robert prime (with gregorio magnani) from 1996 until the end of 1999. robert prime exhibited work by international artists, most of whom had not had a show in london before; among them kai althoff, angela bulloch, general idea, isa genzken, liam gillick, dominique gonzalez-fœrster, lothar hempel, candida höfer, jim isermann, philippe parreno and monique prieto.

corvi-mora opened with a two–person exhibition of work by larry clark and bruce weber. over the past two years the gallery programme has included solo exhibitions of work by monique prieto, barry le va, richard hawkins, liam gillick, jason meadows, brian calvin, roger hiorns, glenn sorensen and jim isermann.

2

3

4

6

5

info@anthonyreynolds.com e-mail

bus nº 7 8 10 25 55 73 98 176

line victoria bakerloo central

tube oxford circus

020 7439 2201 phone

020 7439 1869 fax

4

60 GREAT MARLBOROUGH STREET W1F 7BG

ANTHONY REYNOLDS GALLERY

open tue»sat

contact

anthony reynolds

10–6

artists eija–liisa ahtila ∘ mark alexander ∘ david austen ∘ richard billingham ∘ ian breakwell ∘
erik dietman ∘ keith farquhar ∘ leon golub ∘ paul graham ∘ georg herold ∘ andrew mansfield ∘
alain miller ∘ lucia nogueira ∘ nancy spero ∘ jon thompson ∘ amikam toren ∘ nobuko tsuchiya ∘
keith tyson ∘ mark wallinger ∘ john wilkins

anthony reynolds gallery represents the front line of international
contemporary art. apart from the 20 artists exclusively represented
by the gallery, the work of over 200 artists has been presented
in more than 150 exhibitions over 17 years. at any one time the
gallery usually has at least 30 exhibitions in planning or execution
all over the world.

best known for the discovery of exceptional young artists and the
development of their careers over the long term, the gallery has also
focused on the work of true independents of all generations, in all
media. the only guiding principles in selecting an artist have been
an instinctive conviction about the importance of their work and
a perception that within their chosen area of endeavour they are
leading the field. therefore there is no stylistic thread running
through the programme, but strong elements of surprise,
independence and aesthetic and intellectual stimulation link the
exhibitions. many of our artists were first exhibited here and have
since gone on to become major figures in the international arena.

the gallery was established in a large space near the city in 1985
and moved to the west end in 1990. the great marlborough street
building opened in september 2002 and has a unique character
that reflects the singularity of our standpoint.

image courtesy of anthony reynolds gallery, london

[1] external view of the gallery

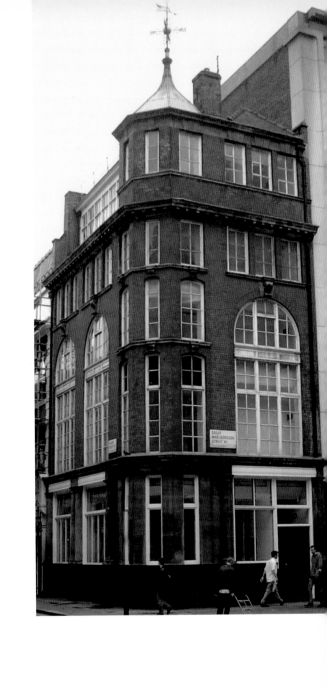

bus n° 9 10 13 14 15 19 22 23 113

line central jubilee bakerloo victoria picadilly

tube bond street green park oxford circus

mail@ttgallery.com
www.ttgallery.com
020 7409 3344
020 7409 1316

5

I BRUTON PLACE WIJ 6LS

TIMOTHY TAYLOR GALLERY

oper

contact tim taylor, terry danziger-miles, faye fleming, charmine farmanfarma

artists craigie aitchison ◦ michael andrews ◦ miquel barceló ◦ jean-marc bustamante ◦
james lee byars ◦ lucian freud ◦ philip guston ◦ roni horn ◦ alex katz ◦ willem de kooning ◦
guillermo kuitca ◦ jonathan lasker ◦ matthias müller ◦ fiona rae ◦ james rielly ◦ julian schnabel ◦
sean scully ◦ joel shapiro ◦ tony smith ◦ mario testino

the timothy taylor gallery opened in 1996 with an ambitious
programme of exhibitions by international artists including
jonathan lasker, sean scully and julian schnabel. central to this
programme were also younger and less-established artists such as
guillermo kuitca and juan uslé, as well as the photographer mario
testino. over the last two years the gallery's profile has developed
further to include relationships with the estates of willem de
kooning, philip guston, tony smith and james lee byars. in the
last year we have extended our representation of artists to include
jean-marc bustamante, roni horn, alex katz, matthias müller,
fiona rae, james rielly and joel shapiro. in spring 2000 we began
a programme of group shows to support and showcase the work
of less established artists. young london-based artists that we have
shown and with whom we have an ongoing relationship include
sophie von hellermann and markus vater.

working closely with our artists, we organise extensive solo and
group exhibitions, not only in our own gallery space but also with
other museums and non-commercial art institutions. we represent
our artists at many of the major contemporary art fairs. plans
for this year include 'art miami basel' and the art forum berlin.
the gallery also aims to provide a wide range of services to our
clients in the building and management of a collection.

all images courtesy timothy taylor gallery, london

[1] james rielly, happy days, 2002 oil on canvas, 121.9×106.7cm

[2] jean-marc bustamante, T.8.01, 2002 C-print, 240×160cm

[3] matthias müller, phantom, 2001 DVD-R (PAL), colour, sound, 4:35 min loop, edition of 5

[4] fiona rae, lovesexy, 2001 oil, acrylic and glitter on canvas, 246×203.5cm

[5] jonathan lasker, expressive structures, 2002 oil on linen, 152.4×203.2cm

I

2

3

4

5

info@entwistle.net
www.entwistlegallery.com
020 7734 6440
020 7734 7966

bus 9 10 13 14 15 19 22 23 113
line victoria jubilee bakerloo piccadilly
tube green park piccadilly circus

6

6 CORK STREET W1S 3EE

ENTWISTLE

open

contact lance entwistle, roberta entwistle, monica chung, darren flook, lora rempel

artists sue arrowsmith ▫ jason brooks ▫ patty chang ▫ sarah dobai ▫ dan hays ▫ anton henning ▫
dan holdsworth ▫ rosa loy ▫ alan michael ▫ tatsuo miyajima ▫ conrad shawcross ▫ dj simpson ▫
gerhard stromberg ▫ michael stubbs ▫ yoshihiro suda

2

entwistle and its subsidiary in tokyo focus on international
contemporary art and represent both emerging and
mid-career artists.

all images courtesy entwistle, london

1 dan holdsworth, untitled, 1998 C-print, 92×114.5cm

2 yoshihiro suda, 'one hundred encounters, entwistle, london', 2001
painted on wood, size according to site

3 dan hays, colorado impression xa (after dan hays, colorado), 2002
oil on canvas, 152×200cm

4 tatsuo miyajima, floating time V2-C-20, 2002 CD-rom

5 jason brooks, sergio, 2001 acrylic on linen, 203.2×154.9cm

I

3

4

5

bus nº 9 10 13 14 15 19 22 23 113

line *victoria jubilee bakerloo piccadilly*

tube green park piccadilly circus

7

contact

mhw@btinternet.com e-m

www.mhwfineart.com

020 7434 1318 pho

020 7434 1321 fax

21 CORK STREET WIS 3LZ

MICHAEL HUE–WILLIAMS FINE ART

michael hue-williams

open mo

9.3

sat

10 –

artists tony bevan ∘ steven cox ∘ susan derges ∘ elger esser ∘ andy goldsworthy ∘ cai guo-qiang ∘ richard misrach ∘ vik muniz ∘ magdalene odundo ∘ josé maría sicilia ∘ hiroshi sugimoto ∘ james turrell

michael hue-williams fine art limited was founded in 1993 and opened its first gallery in bond street. after running a project space in cork street the gallery relocated in 1996 to its present first-floor premises, which were designed by the minimalist architect john pawson.

the gallery works with a broad range of international contemporary artists, such as tony bevan, james turrell and andy goldsworthy, whose practices reflect notions of landscape and architecture. many of the artists also employ distinctive materials for realising their work. james turrell, for example, works with light and space, andy goldsworthy with the natural environment and cai guo-qiang with gunpowder. a number of the artists who work with the gallery also employ specific processes to realise their work, such as turrell's preoccupation with the process of seeing light, the exploration of photographic and non-photographic processes in the images of susan derges, and the inventive choice of materials in the photographs of vik muniz.

over the last five years the gallery has also published comprehensive monographs and artists' books on the work of susan derges, james turrell and tony bevan.

all images courtesy michael hue-williams fine art & the artist

[1] *vik muniz, ad reinhardt, 2000 from 'pictures of dust' series 122×157.5cm, cibachrome print*

[2] *andy goldsworthy, london wall, 2001 25m, clay and hair, installed at barbican art gallery*

[3] *tony bevan, blue interior, 2002 183.75×207.6cm, acrylic on canvas*

[4] *cai guo-qiang, ode to joy, 2002 gunpowder on rice paper*

[5] *james turrell, hover, from 'structural cut' series, 1983 installed at musée d'art moderne de la ville de paris*

I

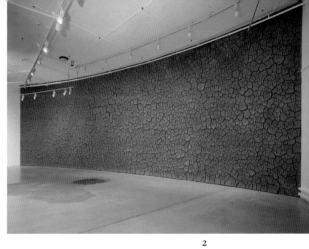

2

3

4

5

info@stephenfriedman.com e-mail

bus n° 9 10 13 14 15 19 22 23 113 www.stephenfriedman.com

line victoria jubilee bakerloo piccadilly 020 7494 1434 phone

tube green park piccadilly circus 020 7494 1431 fax

8

25–28 OLD BURLINGTON STREET W1S 3AN

STEPHEN FRIEDMAN GALLERY open tue»fri

contact stephen friedman, david hubbard, patricia kohl, kirsten macdonald bennett 10–6

sat

11–5

artists mamma andersson ◦ stephan balkenhol ◦ tom friedman ◦ kendell geers ◦ dryden goodwin ◦ thomas hirschhorn ◦ jim hodges ◦ corey mccorkle ◦ beatriz milhazes ◦ donald moffett ◦ yoshitomo nara ◦ rivane neuenschwander ◦ catherine opie ◦ vong phaophanit ◦ michal rovner ◦ yinka shonibare ◦ david shrigley ◦ kerry stewart ◦ rudolf stingel

since 1995 stephen friedman gallery has brought a different perspective to london's west end with a wide-ranging stable of artists. the gallery shows artists from all over the world, and the artists represented range from vong phaophanit, shortlisted for the 1993 turner prize, to the american artist tom friedman. this year, three of the gallery's artists exhibited at 'documenta xi': thomas hirschhorn, kendell geers and yinka shonibare.

stephen friedman gallery aims to promote the work of artists who are thoughtful and intelligent and who produce work that is at once visually stimulating and intellectually challenging. the result is a gallery that is infused with energy and an aesthetic that is oddly compelling and strangely beautiful.

all images courtesy stephen friedman gallery, london

[1] yoshitomo nara, no way!, 2001 crayon and pencil on paper, 25.5x21cm

[2] david shrigley, untitled (fuck the world), 2000 ink on paper, 39.5x35.5cm

[3] david shrigley, untitled (do you like the pictures), 2000 ink on paper, 33.4x29.5cm

[4] yoshitomo nara, baby rock me!, 2001 pencil and crayon on paper, 21x30cm

1

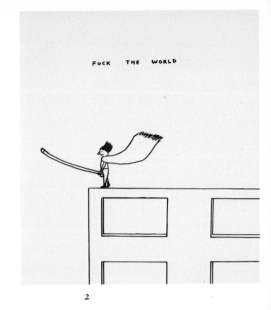

2

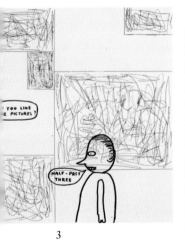

3

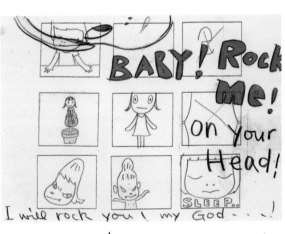

4

info@aspreyjacques.com

www.aspreyjacques.com

020 7287 767

020 7287 7674

bus n° *18 27 30 88 10 24 29 73 134*

lıne *victoria jubilee bakerloo piccadilly*

tube green park piccadilly circus

4 CLIFFORD STREET WIX IRB

ASPREY JACQUES

ope

contact

charles asprey, alison jacques

artists nader ahriman ◦ candice breitz ◦ john chilver ◦ christian flamm ◦ pamela fraser ◦
thilo heinzmann ◦ ian kiaer ◦ tania kovats ◦ graham little ◦ michel majerus ◦ antje majewski ◦
estate of robert mapplethorpe ◦ paul morrison ◦ alessandro raho ◦ jane simpson ◦ catherine yass

asprey jacques was founded in 1998 by charles asprey and alison
jacques. charles asprey was co-founder of riding house editions in
london and alison jacques was curator at the british school at rome,
having previously trained with waddington galleries. the gallery has
an international programme which includes a focus on young artists
from berlin: the opening show was manfred pernice and the gallery
subsequently showed and now represents christian flamm, thilo
heinzmann, michel majerus, antje majewski and nader ahriman.

photography has become an increasingly important part of the
programme. in 1999, asprey jacques became the first young gallery
to work with the estate of robert mapplethorpe, focusing on
the 'polaroids', a body of work made during the early seventies.
asprey jacques also represents catherine yass, who is currently
shortlisted for the 2002 turner prize.

Many of the gallery's british stable of artists who now exhibit on an
international level have worked with asprey jacques since they were
at art school: ian kiaer (ICA, boston 2002); graham little (MoMA, new
york 2002); paul morrison (southampton city art gallery, magasin
grenoble 2002); and alessandro raho (kunsthalle, basel 2002). the
gallery also publishes books, including monographs on antje
majewski, paul morrison and catherine yass, with future
publications on ian kiaer and robert mapplethorpe in the pipeline.

image courtesy asprey jacques, london

[1] *paul morrison, needle, 2002 acrylic on canvas, 229×152.5cm*

office@laurentdelaye.com
www.laurentdelaye.com
020 7287 154
020 7287 156

bus 9 10 13 14 15 19 22 23 113
line victoria jubilee bakerloo piccadilly
tube green park piccadilly circus

10

11 SAVILE ROW W1S 3PG

LAURENT DELAYE GALLERY open

contact lee johnson, aldo rinaldi

artists rut blees luxemburg ∘ mark dean ∘ andrew lewis ∘ philippe mayaux ∘ chad mccail ∘ janice mcnab ∘ grayson perry ∘ vanessa jane phaff

the gallery was founded in february 1996 by laurent delaye in a four-storey warehouse space in st christopher's place, london w1. From the start its programme focused on solo shows of young british and international artists. it also produced a string of curated group shows which brought together leading artists of the british and american scene, promoted alternative publications, and organised two experimental cinema retrospectives. during this period, the gallery began to form its portfolio of artists, many of whom have since emerged as leading figures in their field. in 2000 the gallery relocated to a new venue in savile row.

devoting its energies to presenting new contemporary art practice through a diverse range of approaches and media, the gallery focuses on exposing and defining new tendencies at work in our present context. the emphasis is on promoting young artists, and bringing them to international recognition, through an active engagement with museums and public collections, in the UK and europe especially. the gallery has also developed a private advice-bureau for collectors, informing them of new trends and practitioners as well as dealing privately with more established works. the programme of the gallery is often content-driven and politically charged, with a portfolio that includes artists as diverse as grayson perry, chad mccail, rut blees luxemburg, mark dean, andrew lewis, janice mcnab and philippe mayaux.

all images courtesy of laurent delaye gallery, london; [5] courtesy of the stedelijk museum, amsterdam

[1] andrew lewis, race-ism, 2002 wood, cardboard and paint, 188×76×76cm

[2] rut blees luxemburg, the red mass, 2000 light-box, 137×180cm

[3] chad mccail, the ancient sex curse poisons the root, 2001−02 from the series 'snake', digital print on fuji archival paper, 187.96×127cm

[4] grayson perry, fatherland, 2002 earthenware, 54×35cm

[5] andrew lewis, white van men, 2002 wood, cardboard and paint

1

2

ancient sex curse poisons the root

3

4

5

bus n° *12 13 23 159*

lıne *piccadilly*

tube *piccadilly circus*

info@gagosian.com

www.gagosian.com

020 7292 8222

020 7292 822c

8 HEDDON STREET WIB 4BU

GAGOSIAN GALLERY open

contact

mollie dent-brocklehurst, mark francis, stefan ratibor

opened in 1979 by larry gagosian, gagosian gallery is now considered one of the foremost modern and contemporary art galleries in the world. it is renowned for its beautiful gallery spaces. the gallery in los angeles was designed by richard meier; the two galleries in new york were designed by richard gluckman and new york architects; and the gallery in london was created by caruso st john.

gagosian gallery features modern and contemporary art, paintings, sculpture, photography, mixed-media installations and works on paper by primarily postwar american and european artists. some recent and forthcoming exhibitions in new york, los angeles and london include presentations of work by ghada amer, richard artschwager, georg baselitz, vanessa beecroft, cecily brown, chris burden, francesco clemente, philip-lorca di corcia, michael craig-martin, dexter dalwood, peter davies, eric fischl, douglas gordon, arshile gorky, damien hirst, howard hodgkin, anselm kiefer, jeff koons, maya lin, walter de maria, ed ruscha, david salle, jenny saville, julian schnabel, richard serra, elisa sighicelli, david smith, mark di suvero, philip taaffe, cy twombly, andy warhol, franz west and richard wright.

other locations:

980 madison avenue, new york, 10021 phone 212 741 1111

555 west 24th street, new york, 10011 phone 212 744 2313

456 north camden drive, beverly hills, CA 902190 phone 310 271 9400

[1] *howard hodgkin, on the rocks, 2002 oil on wood, 46.25×56.7cm*

[2] *howard hodgkin, deep purple, 2002 oil on wood, 43.4×53.3cm*

[3] *howard hodgkin, low tide, 2002 oil on wood, 42.5×55cm*

1

2

3

sadie@sadiecoles.com

www.sadiecoles.com

020 7434 2227

020 7434 2228

35 HEDDON STREET WIB 4BP

SADIE COLES HQ

oper

sadie coles, pauline daly

artists carl andre ∘ john bock ∘ don brown ∘ jeff burton ∘ liz craft ∘ john currin ∘ steven dowson ∘ keith edmier ∘ angus fairhurst ∘ urs fischer ∘ felix gonzalez-torres ∘ jonathan horowitz ∘ david korty ∘ jim lambie ∘ sarah lucas ∘ hellen van meene ∘ victoria morton ∘ jp munro ∘ laura owens ∘ simon periton ∘ raymond pettibon ∘ elizabeth peyton ∘ richard prince ∘ ugo rondinone ∘ gregor schneider ∘ daniel sinsel ∘ andreas slominski ∘ nicola tyson ∘ tj wilcox ∘ andrea zittel

sadie coles HQ opened in april 1997 with an exhibition of new paintings by john currin and an installation by sarah lucas, at a time of unprecedented excitement about young contemporary art.

at HQ, located on heddon street in the west end, the focus is on strong individual shows in all media by emerging british, american and european artists. parallel to these exhibitions a programme of off-site projects presents the work of the gallery's artists in a variety of new contexts at locations throughout london and abroad.

HQ has instigated a series of international exchanges with other galleries; these began in 1998 with a residency by the modern institute from glasgow and has since involved swaps in berlin, los angeles, istanbul and tel aviv.

all images © the artist; courtesy sadie coles HQ, london & ⁴ gavin brown's enterprise, NY; ⁵ modern institute, glasgow

[1] *sarah lucas, got a salmon on #3, 1997 R-type photograph*

[2] *victoria morton, untitled, 2002 oil on canvas, 180x150x2.5cm*

[3] *don brown, yoko VII, 2002 acrylic composite and acrylic paint, 114x35.5x30.5cm*

[4] *elizabeth peyton, september(ben), 2001 oil on board, 29.7x22.36cm*

[5] *jim lambie, bed-head, 2002 mattress, buttons, thread, 94x190.5x20.8cm*

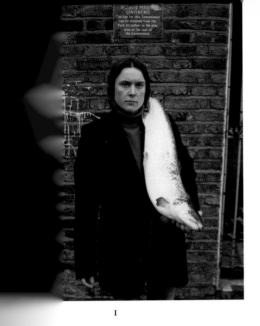

I

2

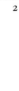

3

4 5

bus nº *9 10 14 19 55*

line *piccadilly bakerloo*

tube *piccadilly circus*

info@emilytsingougallery.com

www.emilytsingougallery.com

020 7839 5320

020 7839 5321

10 CHARLES II STREET SW1Y 4AA

EMILY TSINGOU GALLERY

open

contact

emily tsingou, johanna langen, iben la cour, irene geroyannis

artists michael ashkin ◦ henry bond ◦ kate bright ◦ keith coventry ◦ lukas duwenhögger ◦
karen kilimnik ◦ elke krystufek ◦ dietmar lutz ◦ daniel pflumm ◦ sophy rickett ◦ collier schorr ◦
jim shaw ◦ georgina starr

emily tsingou gallery opened in march 1998, and focuses
on international contemporary art . the gallery design was
a collaboration with peter saville and meure&meure.

the exhibition programme focuses on artists represented by
the gallery, and includes off-site projects such as henry bond's
'la vie quotidienne' (essen and london), georgina starr's video
installation 'bunny lake drive-in' (london), 'emily tsingou gallery'
at praz-delavallade (paris) as well as 'the galleries show',
royal academy of arts (london).

the gallery has also produced books, editions and special projects
with artists including henry bond's 'the cult of the street',
sophy rickett's 'photographs', georgina starr's 'the bunny lakes'
and keith coventry's 'crack' series.

image courtesy of emily tsingou gallery, london

[1] *installation view of inaugural exhibition at emily tsingou gallery, 'karen kilimnik',*
march 1998

bus n° *8 10 19 24 25 38 55 73 176*

line *central northern*

tube **tottenham court road**

info@frithstreetgallery.com

www.frithstreetgallery.com

020 7494 155C

020 7287 3733

59–60 FRITH STREET WID 3JJ

open

contact

FRITH STREET GALLERY

jane hamlyn, kirsten dunne

artists chantal ackerman ∘ fiona banner ∘ dorothy cross ∘ tacita dean ∘ marlene dumas ∘
bernard frize ∘ craigie horsfield ∘ callum innes ∘ jaki irvine ∘ cornelia parker ∘ giuseppe penone ∘
john riddy ∘ thomas schütte ∘ dayanita singh ∘ bridget smith ∘ annelies štrba ∘ fiona tan ∘ juan uslé

founded by jane hamlyn in 1989, frith street gallery was originally
intended as a space dedicated to showing innovative contemporary
works on paper. since then the gallery has grown considerably
and currently represents 18 artists who work in a wide range of
media, from painting, sculpture and installation to photography,
video and film. one of the most distinctive in london, the gallery
is housed in a series of beautiful period and modern rooms which
occupy the ground and basement floors of two adjoining houses
in soho.

this year fiona banner will be our fifth turner-prize nominee, joining
tacita dean, craigie horsfield, cornelia parker and callum innes.
the gallery's strong commitment to working with artists who
use moving-image and time-based media was highlighted at
'documenta XI' in kassel, where chantal akerman, craigie horsfield
and fiona tan all presented new film installations.

as well as working with established figures, frith street gallery
provides the opportunity to see exhibitions by younger artists
and artists from abroad whose work is rarely seen in this country.

image courtesy frith street gallery, london

[1] *external view of the gallery*

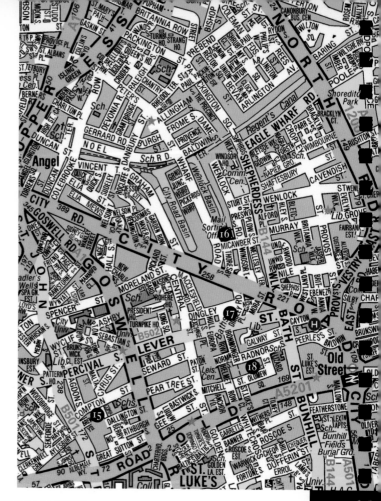

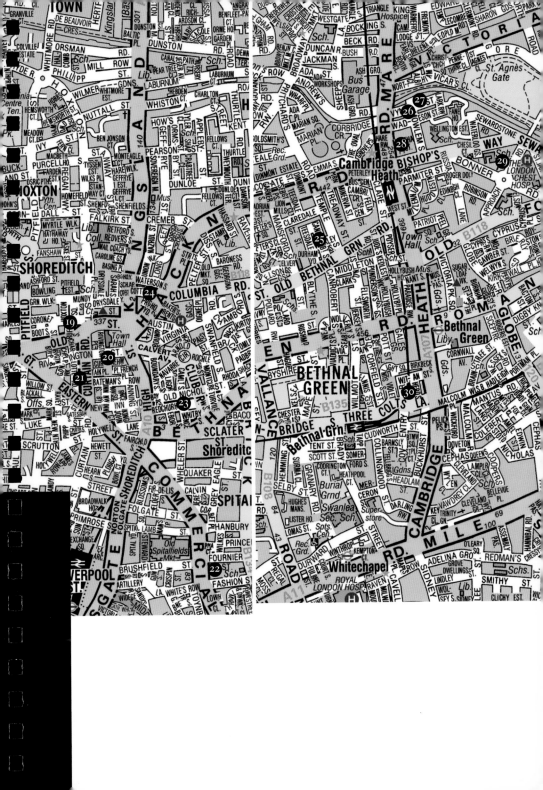

bus 55 243

line *hammersmith&city circle metropolitan*

tube *farringdon barbican*

15

info@andrewmummery.com

www.andrewmummerygallery.com

020 7251 6265

020 7251 5545

63 COMPTON STREET EC1V 0BN

ANDREW MUMMERY GALLERY

open

contact

andrew mummery

artists philip akkerman ◦ chila kumari burman ◦ maria chevska ◦ richard forster ◦ michael fullerton ◦
ori gersht ◦ john goto ◦ alexis harding ◦ peter harris ◦ tim hemington ◦ louise hopkins ◦
merlin james ◦ peter lynch ◦ wendy mcmurdo ◦ ingo meller ◦ alex pollard ◦ carol rhodes ◦
christopher stevens ◦ graeme todd

founded in 1996, the gallery is dedicated to international contemporary art. it represents artists whose work demonstrates an awareness of the culture, history, tradition, conventions and genres of their chosen medium, combined with an ability to re-examine these in the light of contemporary art practice and express something of shared human experience. in a series of occasional exhibitions beginning in september 2002, the gallery will focus on the painters it works with, seeking to place their work in the context of questions raised by the problematic status of painting today. the first of these, 'last chance to paradise', featuring the work of peter davies, alexis harding, peter lynch and ingo meller, looks at the position and continued potential of abstract painting. the second, opening in the middle of october, will be the first london exhibition of the young scottish artist michael fullerton, whose work addresses questions of meaning and is interested in both a contemporary politicised aesthetic and the english rococo world of thomas gainsborough.

for further information about these and other forthcoming exhibitions, and to join our mailing list, please visit our website: www.andrewmummerygallery.com

all images courtesy andrew mummery, london

[1] *peter lynch, sometimes the lightness can just be seen, 2002 oil on canvas, 168x137cm*

[2] *michael fullerton, danny and jimmy waiting for the guy from special branch who bribes them for information with free LSD, 2001/02 oil on canvas, 95x94.5cm*

[3] *alexis harding, collapsed painting, 2002 oil and gloss paint on mdf, 183x152.5cm*

I

2

3

bus nº *214 43*
line *northern via bank*
tube *angel old street*, exit 8

info@victoria-miro.com
www.victoria-miro.com
020 7336 8100
020 7251 5596

16 WHARF ROAD N1 7RW

VICTORIA MIRO GALLERY

open

contact

victoria miro, glenn scott wright

artists doug aitken ∘ anne chu ∘ verne dawson ∘ thomas demand ∘ peter doig ∘ inka essenhigh ∘ ian hamilton finlay ∘ andreas gursky ∘ alex hartley ∘ chantal joffe ∘ isaac julien ∘ udomsak krisanamis ∘ yayoi kusama ∘ abigail lane ∘ robin lowe ∘ dawn mellor ∘ tracey moffatt ∘ hiroko nakao ∘ chris ofili ∘ tal r ∘ adriana varejão ∘ stephen willats ∘ francesca woodman

situated in a converted victorian furniture factory on wharf road, N1, with 8,000 square feet of exhibition space, the victoria miro gallery is one of london's most established and avant-garde commercial galleries. since opening in cork street in 1985 it has built an international reputation upon representing and exhibiting the work of many of today's leading contemporary artists.

the victoria miro gallery launched the careers of british artists chris ofili, peter doig, jake & dinos chapman, and other respected british talents such as abigail lane, dawn mellor, chantal joffe and isaac julien. it also represents senior figures such as ian hamilton finlay and stephen willats. the gallery's established international talents include the german artists andreas gursky and thomas demand, the californian doug aitken, the japanese artist yayoi kusama, the australian artist tracey moffatt, the american artist inka essenhigh and the brazilian adriana varejão. the gallery's philosophy is to take a long-term view with the careers of the artists it represents, seeking to build a critical context for the work both in this country and abroad through working with many of the world's major museums and contemporary art institutions. the new space has allowed the gallery to create an extremely ambitious programme, including the recent critically acclaimed exhibitions by peter doig and chris ofili.

image courtesy the artist & victoria miro, london

[1] *inka essenhigh, sudden arrival of morning, 2001 oil and enamel on canvas, 183x188cm*

oneintheother.art@virgin.net

www.oneintheother.com

020 7253 7882

4 DINGLEY PLACE EC1V 8BP

ONE IN THE OTHER oper

chris noraika

artists guy bar amotz ◦ sam basu ◦ diann bauer ◦ kevin francis gray ◦ simon linke ◦ gary simmonds

the gallery started in 1996 in chris noraika's studio in a turn-of-the-century industrial property in the huguenot district of the east end. its primary concern was the dissemination of ideas around new work by a growing community of artists. because there was no need to develop individual careers, the shows formed a dialogue of their own making. as a result, it became clear that the body of shows were more than just a transient artists' forum, and the programme agglutinated into a cohesive grouping of ideas and artists. the gallery expanded, culminating in the building of the new 'one in the other' space in 2001.

though one in the other works with a core group of its own artists, it also gives a platform to up-and-coming artists. it also allows established artists from larger galleries the freedom to experiment with different or new works, defining emerging trends among themselves and within an art framework. examples of this have seen shows by michael raedecker, paul noble, chantal joffe and steven gontarski. both the old space and the new have combined bond street professionalism with the often short-lived energy of the east-postcoded artist's space. the change in location has underscored the development of the gallery's ability to bring the complexities of the london art world into the wider context of art discourse and the art market.

all images courtesy one in the other gallery, london

[1] *sam basu, funcuba; moon fungus of jadé, 2000 wax, 40x30cm*

[2] *kevin francis gray, sixpack (detail), 2002 crystal glass, polyurethane, diameter 274x130cm*

[3] *simon linke, the cover of artforum used as a metaphor for the three stages of male development, with papier maché as ID, acrylic and PVA as ego and oil as super ego, 2002 acrylic, pva, papier maché and oil on linen, 91x275cm*

[4] *guy bar amotz, jasmin, 2001 fibreglass, recorders, electronics, 85x160x74cm*

1

2

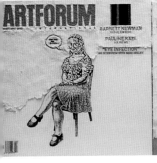
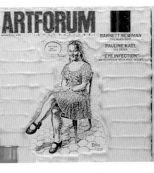
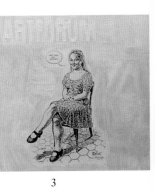

3

4

maxwigram@easynet.co.

bus n° *55 243*

line *northern via bank*

tube **old street**, exit 7

020 7251 31

18

contact

43B MITCHELL STREET EC1V 3QD

MW PROJECTS op

max wigram, soraya rodriguez

artists anna bjerger ∘ marine hugonnier ∘ harland miller ∘ nigel shafran ∘ christian ward

𝔅lack 𝔐agic

I

mw projects was opened by max wigram in december 2001.
the project space was conceived to allow us to work both with artists
we represent and those from other galleries. we run a programme
of exhibitions of the work of emerging artists and of more
established artists, with whom we work on individual projects.

all the projects we take on involve the making of new work; these
include hugonnier's trip to alaska in order to photograph tomorrow
across the international date line, bjerger's series of white paintings,
and noble & webster's first edition of prints.

mw projects is actively involved in curating exhibitions outside its
space, producing exhibitions curated by its own artists and working
privately on building personal collections. upcoming projects
include gary webb, nigel shafran and hiroshi sugito.

all images courtesy the artists & mw projects, london; [1, 4] *courtesy modern art inc, london*

[1] *tim noble & sue webster, black magic, 2002 wrought iron wall piece, 36x56 cm*

[2] *marine hugonnier, towards tomorrow 3, 2001 lambda print, 130x211 cm*

[3] *anna bjerger, nice people and places, 2001 oil on board, 23.5x17 cm*

[4] *tim noble & sue webster, chocolate drop, from 'black magic', 2002 lithograph, 78x64 cm*

2

3

4

bus n° 5 43 55 243 505

line northern via bank

tube old st, exit 9

enquiries@whitecube.com

www.whitecube.com

020 7930 5373

020 7749 7480

48 HOXTON SQUARE N1 6PB

WHITE CUBE

oper

jay jopling opened the original white cube, in duke street, st james's, in london's west end, in may 1993. located in the most traditional art-dealing street in london, the gallery's exhibition space was a single, plain cube. no artist exhibited more than once. the gallery provided a focused environment in which artists presented a single work of art or coherent body of work. white cube has presented solo shows by the most challenging british artists over the last decade, including darren almond, jake & dinos chapman, tracey emin, lucian freud, gilbert & george, steven gontarski, antony gormley, marcus harvey, mona hatoum, damien hirst, gary hume, tom hunter, runa islam, marc quinn, neal tait, sam taylor-wood, gavin turk and cerith wyn-evans. equally important have been the exhibitions of international artists including franz ackermann, miroslaw balka, ashley bickerton, sophie calle, chuck close, katharina fritsch, nan goldin, ellsworth kelly, clay ketter, julie mehretu, matthew ritchie, doris salcedo, hiroshi sugimoto, fred tomaselli, luc tuymans, jeff wall and terry winters.

a second, larger gallery space was set up in hoxton square in london's east end in april 2000, in a 1920s light-industrial building. here a programme of major solo exhibitions has been punctuated by frequent group shows including 'out there', a survey of 1990s british art; 'settings & players: a study of theatrical ambiguity in american photography'; and 'the unthought known', exploring memory and the trace of experience. in 2002 white cube in hoxton initiated an additional exhibition programme entitled 'inside the white cube'. for its inaugural year, the international curator louise neri was invited to develop and present this programme.

all images courtesy jay jopling/white cube, london

1 'the unthought known', 2002 installation shot, white cube, hoxton square

2 julie mehretu, renegade delirium, 2002 acrylic on canvas, 228.6x365.8cm
installation shot, white cube, duke street, st james's

3 'out there', 2000 installation shot, white cube, hoxton square

4 sam taylor-wood 'mute', 2001 installation shot, white cube, hoxton square

5 katharina fritsch, mönch (monk), 1997–99 polyester and paint, 193x58.5x43.2cm,
installation shot, white cube, duke street, st james's

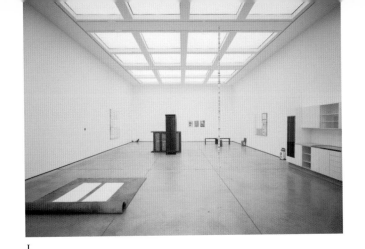

1

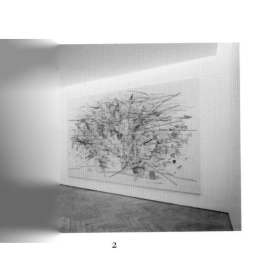

2

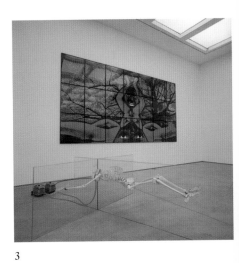

3

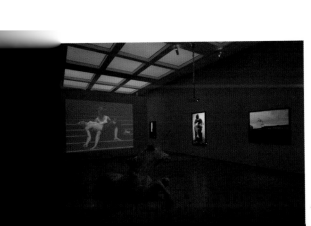

4 5

bus n° 48 55 242

line *northern via bank central circle metropolitan*

tube **old street liverpool street**

mail@vilmagold.com

www.vilmagold.com

020 7613 1609

020 7256 1242

66 RIVINGTON STREET EC2A 3AY

VILMA GOLD

open

contact

rachel williams, steven pippet

artists shahin afrassiabi ∘ jemima and dolly brown ∘ stephen cornell ∘ dubossarsky and vinogradov ∘ brian griffiths ∘ daniel guzman ∘ sophie von hellermann ∘ hobbypopMUSEUM ∘ ben judd ∘ colin lowe and roddy thomson ∘ andrew mania ∘ mark titchner ∘ markus vater

the gallery began by concentrating on the work of a loosely knit group of artists whose practices had, since the mid-1990s, been closely associated with london's artist-run space phenomenon. it now collaborates internationally with artists and galleries working in a similar vein.

image courtesy vilma gold, london

[1] *dubossarsky and vinogradov, baby i'm still in the office, 1996 oil on canvas, 145x180cm*

[2] *colin lowe and roddy thomson, the dark throttle, 2002*

mixed media with bar snacks, 210x150x270cm

bus n° *26 48 55 74*

line *northern via bank*

tube **old street**

theagencyltd@agency-gallery.demon.co.uk e-ma

www.agency-gallery.demon.co.uk

020 7613 2080 phor

&fax

contact

35–40 CHARLOTTE ROAD EC2A 3DH

THE AGENCY. CONTEMPORARY LTD

bea de souza

open tue»

11–6

artists faisal abdu'allah ◦ heather burnett ◦ kazuo katase ◦ annika larsson ◦ zoe leonard ◦ ken lum ◦
seamus nicholson ◦ zineb sedira ◦ ross sinclair ◦ thaddeus strode ◦ raymond yap

one of the first commercial spaces to open in the shoreditch area,
the agency shows international contemporary art across a range
of media: video, installation, sculpture, photography, and painting.
many of the gallery artists are represented in public collections,
both in the UK and abroad, and their work has been shown
in international exhibitions, including the venice biennale and
'documenta'. the gallery regularly attends major commercial art
fairs in europe.

since moving to its present address in 1995, the gallery has been
recognised for its bold approach to contentious political and cultural
issues. although there is no attempt to follow an overt agenda,
the agency now has a definite focus on artists like ken lum, zineb
sedira, and raymond yap, whose work explores the themes of
transnationalism and cultural identity. the politics of representation
is further investigated by artists such as faisal abdu'allah, whose
work explores issues of race, and heather burnett, who focuses on
the portrayal of violence and atrocity, both in 'real life' news media
and entertainment media. other artists explore what might be
called the politics of geography: ross sinclair's installations and
photographs combine sloganeering and a humorous reconfiguration
of culturally charged spaces, while seamus nicholson's photographs
capture a nocturnal sense of urban alienation.

images courtesy the agency. contemporary ltd & [3,4] private collection

[1] *zineb sedira, silent sight (detail), 2000 12–minute b&w DVD projection*

[2] *ken lum, grace chung financial, 2001*

perspex, enamel paint, plastic letters, aluminium, 198cm²

[3] *ross sinclair, i love real life (white), 2001 neon, perspex, transformer, wiring, 20×125×4cm*

[4] *faisal abdu'allah, grace (from 'still-life' series), 2000*

photo-screen print on graphite slate and copper plate, 58.5×53.5×2cm

[5] *seamus nicholson, heidi, 2001 C-type print, 104.5×156.5cm*

1

2

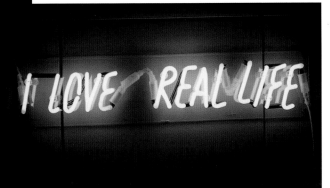

3

4

5

anybody@magnani.co.uk e-m

bus n° 67

lne *central metropolitan hammersmith&city circle district* 020 7375 3002 pho

tube liverpool street aldgate east 020 7375 3006 fax

22

82 COMMERCIAL STREET E1 6LY

MAGNANI open tue>

contact gregorio magnani 11—

artists kai althoff ∘ angela bulloch ∘ vidya gastaldon ∘ isa genzken ∘ dominique gonzalez-fœrster ∘ lothar hempel ∘ candida höfer ∘ scott king ∘ christina mackie ∘ jean-michel wicker

magnani opened in may 2001 with a solo show by angela bulloch. since then we have presented exhibitions by isa genzken, vidya gastaldon, scott king and lothar hempel.

from september 2002 the gallery will pursue two parallel programmes. it will continue to represent a small number of artists and perform all those functions that are expected of a commercial gallery: already planned are solo shows by christina mackie, jean-michel wicker and candida höfer. at the same time, we will start a programme of exhibitions with no commercial aim. the first, addressing a notion of enduring presence, will include works as diverse as a roy lichtenstein 'mirror painting', a cast of princess mathilde bonaparte's hand, a sherrie levine 'after matisse' sketch, a plaster portrait of contessa di castiglione as etruria, and a signature work by marcel duchamp, as well as specially designed contributions by a number of younger artists. a second show will take klossowski's 'diana and acteon' as its starting point.

[1] *scott king, 'otl aicher's oversight (munich 1972)', 2002 silkscreen on paper, 127cm²*

[2] *isa genzken, new buildings for berlin, 2001*

glass, wood, tape, paint, circa 223x45x60cm each, installation view

[3] *lothar hempel, laisser-faire, 2002 various materials, dimensions variable, installation view*

[4] *angela bulloch, matrix, bullet dodge, bullet stop, 2001 waxed birch wood, printed aluminium*

sheet, glass, cables, rgb light system, dimensions variable, installation view

1

2

3

4

bus n° 8 26 55 242

line central northern

tube liverpool street old street

modernart@easynet.co.uk

www.modernartinc.com

020 7739 2081

020 7729 2017

73 REDCHURCH STREET E2 7DJ

oper

contact

MODERN ART

detmar blow, stuart shave

artists simon bill ∘ mat collishaw ∘ nigel cooke ∘ ian dawson ∘ david falconer ∘ nic hess ∘ brad kahlhamer ∘ martin kersels ∘ barry mcgee ∘ jonathan meese ∘ tim noble & sue webster ∘ erik parker ∘ eva rothschild ∘ juergen teller ∘ clare woods ∘ richard woods

modern art was opened in november 1998 by stuart shave and detmar blow at 73 redchurch street in the centre of east london's bangladeshi community.

over the past three years we have worked on several off-site projects including a collaborative presentation at modern art and chapman fine arts of work by david falconer, 'ultra violet baby' by mat collishaw at shoreditch town hall, 'almost american' by brad kahlhamer at hoxton house, and a public billboard project with juergen teller at old street roundabout.

modern art seeks to manage all aspects of our artists' careers and to assist them in the realisation of special projects . we encourage collaborative ventures and exhibit international artists who have never before shown in london . foremost, we advocate dialogue between artists, art collectors, galleries, writers and museums.

our forthcoming season will include san franciscan street artist barry mcgee, swiss installation artist nic hess, american-indian painter brad kahlhamer and london-based sculptor ian dawson.

image courtesy modern art, london

[1] *richard woods, tabley house, 2000 installation view*

bus n° 26 48 55

line northern circle metropolitan hammersmith&city

tube old street liverpool street

mail@rhodesmann.com
www.rhodesmann.com

020 7729 4372
020 7729 4754

37 HACKNEY ROAD E2 7NX

RHODES+MANN

open

contact

benjamin rhodes, fred mann, tim hutchinson

artists lolly batty ○ nayland blake ○ calum colvin ○ layla curtis ○ robert davies ○ kate davis ○ ashley elliott ○ till exit ○ michael ginsborg ○ david godbold ○ erik hanson ○ oliver herring ○ paul huxley ○ bill jacobson ○ mark jennings ○ des lawrence ○ melanie manchot ○ david schnell

rhodes+mann formed in may 2000, when benjamin rhodes (ex jason & rhodes) and fred mann (milch) joined forces. the gallery comprises 3000 square feet of exhibition space spread over two floors. the ground floor has a large exhibition area and a separate viewing room for visiting clients to view works from stock. below this is a further gallery space and project room.

rhodes+mann is one of the largest private gallery spaces in london, showing a cross-section of photography, sculpture, installation, sound art, video and painting. the gallery represents international established and emerging artists, giving them critical and practical assistance in presenting their work. the aim is to increase awareness of the artists' practice, both in london and internationally, and to develop strong links with other national and international museums, writers and curators.

in addition to generating sales, and placing works in major collections, the gallery also promotes new commissions and produces publications and print editions.

rhodes+mann, at 37 hackney road, is in the heart of today's contemporary art community.

all images courtesy of rhodes+mann, london

[1] des lawrence, robert stephens obituary portrait, 2000 silverpoint on paper, 153.5×135.4cm

[2] kate davis and till exit, 2000 installation view

[3] david godbold, john greenwood and nayland blake, in 'drawings', 2001 installation view

[4] lolly batty and paul huxley, 2001 installation view

[5] layla curtis, world state (detail), 2000 collaged US topographical maps, 183x106cm

1

2

3

5

4

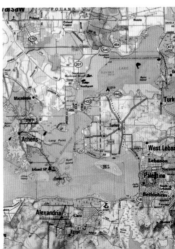

bus *D6 26 48 55 106 253*

line *central*

tube **bethnal green**

jari@vtogallery.com e-ma

www.vtogallery.com

020 7729 5629 phon

08701 245 382 fax

25

96 TEESDALE STREET E2 6PU

VTO open fri » s

contact jari lager 11–6

artists florain balze ∘ tobias collier ∘ volker eichelmann ∘ john isaacs ∘ klaus theijl jakobsen ∘
eva karapanou ∘ peter klare ∘ unna knox ∘ tonico lemos auad ∘ myfanwy macleod ∘ mike marshall ∘
stefan nikolaev ∘ matt o'dell ∘ shannon oksanen ∘ ben pruskin ∘ wolfgang stehle ∘ corin sworn ∘
eva weinmayr ∘ simon wood

VTO was formed in 1998 to allow upcoming artists from britain
and abroad, whose work crosses the borders of several media, to
realise installation projects and exhibit new work. VTO has a 1500
square foot gallery space, situated on the first floor of an east-end
warehouse in london. since 1998 it has presented numerous solo
exhibitions and several group shows. in the last few years the gallery
has increasingly gained a commercial orientation and has already
participated in numerous art fairs abroad.

all images courtesy of the artist and VTO

[1] *john isaacs, dumb planets are round too, 2002*

fibre-optic lights, foam, wood, steel, polystyrene, video installation, 320x155x195cm

[2] *tobias collier, coffee cosmology, 1999 video installation with sound, variable dimensions*

[3] *simon wood, guzzler, 2001 painted cooker, 160x65x65cm*

[4] *klaus thejll jakobsen, rasen ohne regeln (driving without rules)–mario cart, 2002*

pothole, stripes and wax, 135x430cm

[5] *simon patterson, le match des couleurs, 2000 video installation, DVD version, edition of 3*

1

2

3

4

5

bus 26 48 55 106 D6 253

line *central*

tube **bethnal green**

nylon@btinternet.com e-mail

www.nylongallery.com

020 8983 5333 phone

020 8983 5444 fax

IO VYNER STREET E2 9DG

NYLON open thur » sun

26

contact mary-jane aladren . 12–6

artists kate belton ◦ cornford & cross ◦ craig fisher ◦ paul housley ◦ twan janssen ◦ roger kelly ◦ rory macbeth & darren phizacklea ◦ jason middlebrook ◦ alex morrison ◦ gail pickering ◦ guy richards smit ◦ adam ross ◦ john strutton ◦ twentieth century

nylon was founded in 1998 in the home of mary-jane aladren in shepherds bush and, inspired by the brooklyn-based gallery pierogi 2000, began originally by housing 'flatfiles' of works on paper. the project grew very quickly, and soon nylon was showing works in other media . in 2001 nylon relocated to a larger space in bethnal green in the east end.

the nylon programme specialises in revealing contemporary work by artists based largely in new york and london, although this list has now broadened to include artists, such as twan janssen, alex morrison and adam ross, who are based in other cities . nylon is particularly interested in collaborative work and has shown various artists 'in synthesis', namely cornford & cross, dj simpson & david burrows and the 12-person group twentieth century . nylon has now participated in a number of international art fairs including the armory in new york, liste in basel, and artissima in turin.

every january, nylon invites an up-and-coming curator to take over the space and curate a show . so far these curators have included michael wilson, klega, gavin wade and simon morrissey and the artists adam dant, per huttner, goshka macuga, cornelia parker and bettina von zwehl . this has given the programme a certain freedom, allowing it to remain eclectic and engage with a variety of cross-currents in artistic practice as they emerge.

all images courtesy of the artist and nylon, london

[1] *jason middlebrook, 'visible entropy III: three types of debris', june 2002 installation view*

[2] *twentieth century, trojan squirrel, november 2001 installation view*

[3] *paul housley, quiet lady of the woods, 2002 oil on canvas, 91×122cm*

[4] *john strutton, from the series '77 7″singles', 2001/02 watercolour & gouache on paper, 18cm²*

[5] *roger kelly, crystalline, 2002 pencil, ink and acrylic on canvas, 155×224cm*

[6] *cornford & cross, M20 open day, kent, may 1991 C–print, dimensions variable*

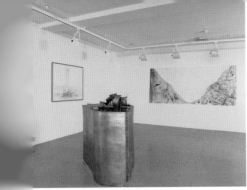

1

2

3

4

5

6

bus *D6 26 48 55 106 253*

line *central*

tube **bethnal green**

info@mobilehomegallery.com e-mail

www.mobilehomegallery.com

020 7405 7575 phone

020 7405 7505 fax

7 VYNER STREET E2 9DG

MOBILE HOME

ronnie simpson

open wed » sun

12–6

contact

artists artlab ◦ alan brooks ◦ nick crowe ◦ mark fairington ◦ magali fowler ◦ andrew grassie ◦
mathew hale ◦ elizabeth price ◦ thomson & craighead ◦ alison turnbull ◦ julie verhoeven

mobile home opened in 1999 representing a new generation
of contemporary artists now making a major impact on the
international arts scene . with an exclusive clientele of international
art collectors and museum directors flying in to pick up the latest
work from artists such as andrew grassie, julie verhoeven, mathew
hale and magali fowler, mobile home's dynamic programme has
ensured its position as one of the hottest galleries in london.

recent exhibitions have included andrew grassie's highly detailed
realist paintings of contemporary art galleries; julie verhoeven's
drawings and installations combining the worlds of art, fashion
and music, recently featured in the fischerspooner performances
at deitch projects, new york; artlab's highly complex homemade
sculptural structures for the display of contemporary art;
thomson & craighead's video and installation pieces working with
mobile telephones and other forms of digital data, recently shown
at tate britain; and mark fairington's exotic and highly elaborate
natural history paintings, which will receive a major solo exhibition
at the natural history museum, london, in 2004.

all images courtesy mobile home, london

[1] *elizabeth price, boulder, 1996– packing tape, dimensions variable (growing)*

[2] *mathew hale, miriam stealing, 2000–02 ink on paper, 212x13cm*

[3] *julie verhoeven, untitled, 2002 ink on paper, 42x29.5cm*

[4] *mark fairington, without shame (burbidgeae), 2001 oil on canvas, 152x92cm*

[5] *magali fowler, whoa!, 2001 iris print, 64x114cm*

[6] *andrew grassie, 'donald judd, untitled 1966', 2002 tempera on paper, 15.3x19.9cm*

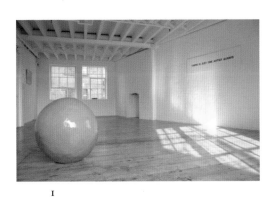

I

2

3

4

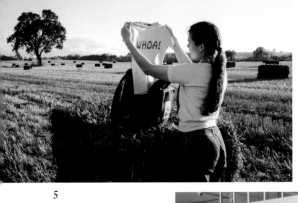

5

6

bus D6 26 48 55 106 253

line *central*

tube **bethnal green**

info@anthonywilkinsongallery.com e-mail

www.anthonywilkinsongallery.com

020 8980 2662 phone

020 8980 0028 fax

242 CAMBRIDGE HEATH ROAD E2 9DA

ANTHONY WILKINSON GALLERY

open thur»sat

contact

anthony wilkinson, amanda knight-adams

11–6

sun

12–6

or by

appt

artists bank ◦ david batchelor ◦ glen baxter ◦ christopher bucklow ◦ brian conley ◦ angela de la cruz ◦
a k dolven ◦ peter ellis ◦ geraint evans ◦ julie henry ◦ matthew higgs ◦ nicky hirst ◦
olav christopher jenssen ◦ kenny macleod ◦ elizabeth magill ◦ silke schatz ◦ george shaw ◦
mike silva ◦ bob & roberta smith ◦ johnny spencer ◦ jessica voorsanger

the anthony wilkinson gallery shows british and international
contemporary art . a separate programme of video art is also
shown in a project space within the gallery, which recently
presented a weekly programme of video work from the late 1960s
to the present day.

images courtesy anthony wilkinson gallery, london

[1] *a k dolven, 2:57, 2002 35mm film on DVD, duration 3.09mins*

theapproach.gallery@virgin.n

www.theapproachgallery.co.t

bus nº *D6 48 55 26 106 253*

lıne *central*

tube **bethnal green**

020 8983 38

020 8983 39

29

IST FLOOR 47 APPROACH ROAD E2 9LY

THE APPROACH op

contact

jake miller

artists **phillip allen** ◦ **dan coombs** ◦ **evan holloway** ◦ **inventory** ◦ **emma kay** ◦ **dave muller** ◦ **jacques nimki** ◦ **michael raedecker** ◦ **tim stoner** ◦ **mari sunna** ◦ **gary webb** ◦ **martin westwood** ◦ **shizuka yokomizo**

the approach is located in a converted function room above a local pub in the east end of london. founded by jake miller in 1997, within a year of its inception the gallery made the transition from artist-run space to representing artists commercially. a relaxed and informal atmosphere is created by entering an elegant gallery space via a pub. the idea was to establish a space which would have a reciprocal relationship with a connected bar, with each retaining its own identity.

one of the gallery's original objectives was to offer solo exhibitions to london-based artists at the start of their careers, several of whom have gone on to achieve international success. the gallery has expanded to represent a number of artists from abroad, in particular the americans evan holloway and dave muller.

miller frequently programmes artist-curated exhibitions. the first was selected by peter doig, and the next, 'a-z', which featured more than 40 artists working with text, was chosen by matthew higgs. 'it's a curse, it's a burden', curated by painter glenn brown, included the work of keith tyson, rebecca warren, george condo and mike kelley, accompanied by an electronic sound track provided by add N to (x).

all images courtesy the approach, london

[1] *gary webb, love on rocks, 2000 plastic, perspex, glass, Q-cell, minidisc, 243×118×183cm*

[2] *phillip allen, beezerspline (extended version), 2001 oil on board, 40×51cm*

[3] *'it's a curse, it's a burden', 1998–1999 curated by glenn brown, installation view*

[4] *gallery entrance*

1

2

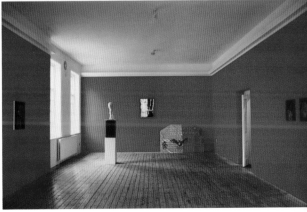

3

4

interim.art@virgin.net e-mail

bus 8 106 253

line *central* 020 7729 4112 phone

tube bethnal green 020 7729 4113 fax

21 HERALD STREET E2 6JT

MAUREEN PALEY INTERIM ART open thur»sun

contact maureen paley, james lavender 11–6

artists ross bleckner ∘ jessica craig-martin ∘ kaye donachie ∘ mark francis ∘ maureen gallace ∘ ewan gibbs ∘ sarah jones ∘ karen knorr ∘ michael krebber ∘ malerie marder ∘ muntean/rosenblum ∘ paul noble ∘ david rayson ∘ paul seawright ∘ hannah starkey ∘ david thorpe ∘ wolfgang tillmans ∘ rebecca warren ∘ gillian wearing ∘ paul winstanley

since september 1999 interim art has been situated in bethnal green in premises of 2,500 square feet, having relocated there from a victorian terraced house in london's east end. the gallery programme began in 1984, promoting and showing art from the US and europe, as well as launching new talent from the UK. notable exhibitions have included hannah collins, helen chadwick, paul winstanley, angela bulloch, gillian wearing, mark francis, jenny holzer, richard deacon, charles ray, georg herold, peter fischli and david weiss, mike kelley with jessica diamond, and matthew antezzo with liam gillick. more recently, the gallery has shown the work of wolfgang tillmans, muntean/rosenblum, sarah jones, hannah starkey, ewan gibbs, david rayson, david thorpe, paul noble and ross bleckner.

maureen paley, the gallery's founder and director, has also curated a number of large-scale public exhibitions. in 1995 'wall to wall' was organised for a national touring exhibition and appeared at the serpentine gallery, london, southampton city art gallery and leeds city art gallery, showing wall drawings. paley also selected an exhibition of work by young british artists called 'the cauldron', featuring christine borland, angela bulloch, jake & dinos chapman, steven pippin, georgina starr and gillian wearing, for the henry moore sculpture trust, which was installed in its studio space in dean clough, halifax, in may–june 1996.

[1, 5] *courtesy maureen paley interim art, london;* [2] *the saatchi gallery, london;* [3] *anita and poju zabludowicz, london;* [4] *susan and lewis manilow, chicago*

[1] *wolfgang tillmans, 2002 installation view*

[2] *rebecca warren, croccioni, 2000 unfired clay and plinth, 85×34×84cm*

[3] *gillian wearing, self-portrait, 2000 C-type print*

[4] *muntean/rosenblum, untitled (strange, the moments), 2002 acrylic on canvas, 200×250cm*

[5] *paul noble, public toilet, 1999 pencil on paper, 275cm²*

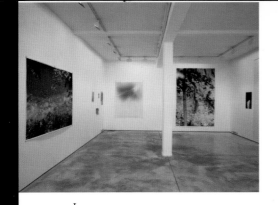

1

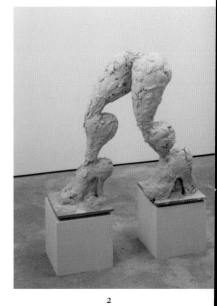

2

3

4

5

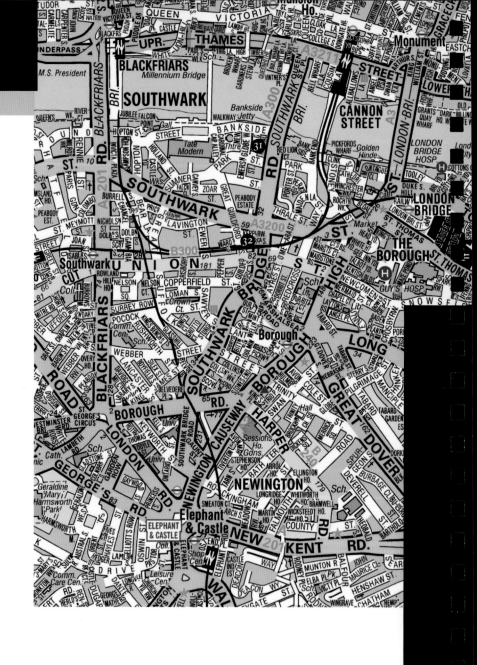

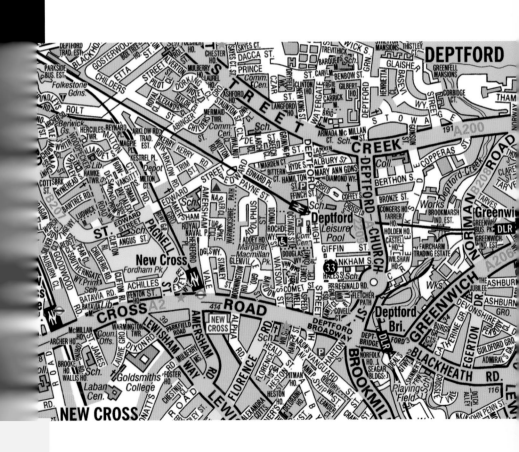

bus nº *5 17 21 35 40 344 381*

line *northern jubilee*

tube *london bridge southwark*

info@faprojects.com

www.faprojects.com

020 7928 3228

020 7928 5123

1–2 BEAR GARDENS SE1 9ED

F A PROJECTS open

contact brooke mcconochy

artists torie begg ◦ david burrows ◦ ellen cantor ◦ thierry fontaine ◦ james ireland ◦ izima kaoru ◦ takehito koganezawa ◦ jo mitchell ◦ matthew smith ◦ grazia toderi ◦ geerten verheus ◦ john wood & paul harrison

1

f a projects opened on bankside, just next to tate modern, in september 2001, with an exhibition of new work by grazia toderi and an exterior neon work by ugo rondinone.

it has since presented an international programme of painting, video, sculpture, photography, drawing, performance and installation exhibitions by artists from the UK and overseas.

f a projects combines artist representation and a commercial programme with an artist residency programme in on-site studio space, and the initiation and management of external projects.

all images courtesy f a projects, london

¹ *jo mitchell, mayhem (distorted pink), 2001 collage, 45×61cm*

² *david burrows, devoid of the fashionable metaphysics of despair, 2001*

polyethelyne foam, 115×87cm

2

bus *21 35 40 133 343*

line *jubilee northern*

tube **london bridge borough southwark**

info@essorgallery.com e-mail

www.essorgallery.com

020 7928 3388 phone

020 7928 3389 fax

I AMERICA STREET SE1 ONE

ESSOR GALLERY open mon » fi

lucinda clark

9–6

sat

10–5

contact

artists jananne al-ani ∘ stefan mauck ∘ thomas ruff

essor gallery opened in september 2001 with an exhibition of works by the german photographer thomas ruff. since then, the gallery programme has reflected its working remit: to show a diverse range of both established and emerging international artists, whose practice covers a spectrum of media and endeavour. artists exhibited include jananne al-ani, dan graham, johan grimonprez, claude heath, majida khattari, stefan mauck, paul mccarthy and benjamin weissman, ivan morley and thomas ruff.

essor gallery is set over roughly 4000 square feet and houses four gallery spaces with an additional entrance gallery. it is complemented by the off-site venue 'essor gallery project space', which is of a comparable size but very different in nature. housed in nearby railway arches the site lends itself to projections, performances, outsize installations and educational art activities with schools and other groups, particularly from the local area. the project space has so far been used for both gallery events and externally curated exhibitions.

within the next few years essor gallery will expand upon its established programme to include exhibitions by artists based beyond europe and the USA, enabling and encouraging projects in the gallery, the project space and the public environment.

all images courtesy essor gallery, london

[1] *stefan mauck, projektionskegel (projection cone), 1998*

 wood, PVC and slide projection, 205×420×54cm

[3] *johan grimonprez, anonymous, st petersburg, february 1993, 1999*

 cibachrome between plexiglass, 74.3×104.1cm

[4] *thomas ruff, w.h.s. 01, 2001 c-print, 185×245cm*

1

2

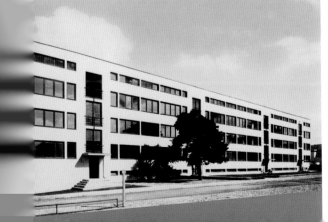

3

info@halesgallery.com e-mail

www.halesgallery.com

bus 36 47 53

line east london 020 8694 1194 phone

tube/rail new cross new cross gate deptford[br] deptford bridge[dlr] 020 8692 0471 fax

33

70 DEPTFORD HIGH STREET SE8 4RT

HALES GALLERY open mon»sat

contact paul hedge 10−5

artists sarah beddington ∘ andrew bick ∘ claire carter ∘ diana cooper ∘ richard galpin ∘ jane harris ∘ hew locke ∘ paul mcdevitt ∘ hans op de beeck ∘ jaime pitarch ∘ ben ravenscroft ∘ danny rolph ∘ michael smith ∘ myra stimson ∘ tomoko takahashi ∘ spencer tunick ∘ jane wilbraham

paul hedge and paul maslin opened hales gallery in 1992 and rapidly established a reputation for showing new and innovative work. the early important solo shows by the chapman brothers, sarah jones and mike nelson (to name a few) happened at hales gallery. the success of these shows between 1992 and 1997 marked the beginning of the transition from an 'alternative space' to a dynamic commercial gallery that represents its own artists. the combination of its south-east london location (close to goldsmiths' college) and the personalities of the founders, together with a proven track record of spotting new talent, has made the gallery a major destination for collectors, critics and artists alike. its uniqueness is complemented by the gallery's café, which boasts its own band, 'spyna workshop', now signed to a major record label.

one of the distinguishing features of hales is the emphasis it places on supporting and encouraging artists from an early stage in their careers. this has led to the nurturing of artists like tomoko takahashi, hew locke, diana cooper and andrew bick.

all images courtesy of hales gallery, london & ⁴ private collection

[1] hans op de beeck, border, 2001 20min video installation, repeated with amplified sound

[2] paul mcdevitt, apeman, 2002 biro on gesso on board, 63x48cm

[3] andrew bick, variant C, 2001 wax, paint and marker pen on wood, 151x122x6cm

[4] jane wilbraham, pleasant aspects, 2000 plastic signs, 48x58x15cm

[5] tomoko takahashi, tennis court piece for 'parklight' at clissold park (detail) 2000 mixed media, dimensions variable

[6] hew locke, cardboard palace, 2002 cut cardboard and paint, dimensions variable

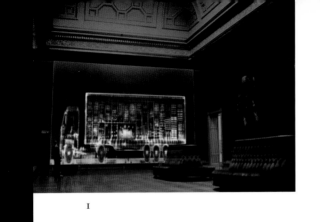

1

2

3

4

5

6

list of artists

faisal abdu'allah 21, tomma abts 2, chantal ackerman 14, franz ackermann 19, shahin afrassiabi 20, nader ahriman 9,

eija-liisa ahtila 4, craigie aitchison 5, doug aitken 16, philip akkerman 15, jananne al-ani 32, mark alexander 4,

phillip allen 29, edward allington 1, darren almond 19, kai althoff 22, francis alÿs 1, ghada amer 11, mamma andersson 8,

carl andre 1 & 12, michael andrews 5, stefano arienti 2, matthew arnatt 2, sue arrowsmith 6, art & language 1, artlab 27,

richard artschwager 11, michael ashkin 13, david austen 4, john baldessari 1, miroslaw balka 19, stephan balkenhol 8,

florain balze 25, bank 28, fiona banner 14, guy bar amotz 17, miquel barceló 5, georg baselitz 11, sam basu 17,

david batchelor 28, lolly batty 24, diann bauer 17, glen baxter 28, sarah beddington 33, vanessa beecroft 11, torie begg 31,

kate belton 26, tony bevan 7, andrew bick 33, ashley bickerton 19, simon bill 23, richard billingham 4, pierre bismuth 1,

anna bjerger 18, nayland blake 24, ross bleckner 30, john bock 12, henry bond 13, christine borland 1, jennifer bornstein 2,

ian breakwell 4, candice breitz 9, kate bright 13, alan brooks 27, jason brooks 6, cecily brown 11, don brown 12, jemima and

dolly brown 20, roddy buchanan 1, christopher bucklow 28, angela bulloch 22, chris burden 11, chila kumari burman 15,

heather burnett 21, david burrows 31, jeff burton 12, jean-marc bustamante 5, james lee byars 5, sophie calle 19,

brian calvin 3, pierpaolo campanini 3, ellen cantor 31, claire carter 33, james casebere 1, patty chang 6, jake &

dinos chapman 19, neil chapman 2, maria chevska 15, john chilver 9, anne chu 16, steven claydon 2, francesco clemente 11,

chuck close 19, tobias collier 25, andy collins 3, mat collishaw 23, calum colvin 24, brian conley 28, nigel cooke 23,

dan coombs 29, diana cooper 33, philip-lorca di corcia 11, stephen cornell 20, cornford & cross 26, keith coventry 13,

steven cox 7, liz craft 12, tony cragg 1, jessica craig-martin 30, michael craig-martin 11, dorothy cross 14, nick crowe 27,

john currin 12, layla curtis 24, dexter dalwood 11, grenville davey 1, peter davies 11, robert davies 24, kate davis 24,

ian dawson 23, verne dawson 16, angela de la cruz 28, richard deacon 1, mark dean 10, tacita dean 14, thomas demand 16,

susan derges 7, erik dietman 4, sarah dobai 6, peter doig 16, a k dolven 28, kaye donachie 30, steve doughton 2,

steven dowson 12, dubossarsky and vinogradov 20, lili dujourie 1, marlene dumas 14, lukas duwenhögger 13,

keith edmier 12, volker eichelmann 25, ashley elliott 24, peter ellis 28, tracey emin 19, inka essenhigh 16, elger esser 7,

rivane euenschwander 8, geraint evans 28, till exit 24, angus fairhurst 12, mark fairnington 27, david falconer 23,

keith farquhar 4, vincent fecteau 2, rachel feinstein 3, ian hamilton finlay 16, urs fischer 12, eric fischl 11, craig fisher 26,

christian flamm 9, ceal floyer 1, thierry fontaine 31, richard forster 15, samuel fosso 2, magali fowler 27, mark francis 30,

pamela fraser 9, lucian freud 5 & 19, tom friedman 8, katharina fritsch 19, bernard frize 14, michael fullerton 15,

giuseppe gabellone 2, maureen gallace 30, richard galpin 33, vidya gastaldon 22, kendell geers 8, isa genzken 22,

ori gersht 15, ewan gibbs 30, gilbert and george 19, liam gillick 3, michael ginsborg 24, david godbold 24, nan goldin 19,

andy goldsworthy 7, leon golub 4, steven gontarski 19, dominique gonzalez-fœrster 22, felix gonzalez-torres 12,

dryden goodwin 8, douglas gordon 1 & 11, arshile gorky 11, antony gormley 19, john goto 15, dan graham 1, paul graham 4,

rodney graham 1, andrew grassie 27, kevin francis gray 17, joanne greenbaum 2, brian griffiths 20, cai guo-qiang 7,

andreas gursky 16, philip guston 5, daniel guzman 20, mathew hale 27, erik hanson 24, alexis harding 15, peter harris 15,

jane harris 33, alex hartley 16, marcus harvey 19, mona hatoum 19, richard hawkins 3, dan hays 6, mary heilmann 2,

thilo heinzmann 9, sophie von hellermann 20, tim hemington 15, lothar hempel 22, anton henning 6, julie henry 28,

georg herold 4, oliver herring 24, nic hess 23, matthew higgs 28, roger hiorns 3, thomas hirschhorn 8, damien hirst 11 & 19,

nicky hirst 28, hobbypopMUSEUM 20, jim hodges 8, howard hodgkin 11, candida höfer 22, dan holdsworth 6,

evan holloway 29, louise hopkins 15, roni horn 5, jonathan horowitz 12, craigie horsfield 14, shirazeh houshiary 1,

paul housley 26, marine hugonnier 18, gary hume 19, tom hunter 19, paul huxley 24, callum innes 14, inventory 29,

james ireland 31, jaki irvine 14, john isaacs 25, jim isermann 3, runa islam 19, bill jacobson 24, merlin james 15,

twan janssen 26, mark jennings 24, olav christopher jenssen 28, chantal joffe 16, sarah jones 30, peter joseph 1, ben judd 20,

donald judd 1, isaac julien 16, brad kahlhamer 23, izima kaoru 31, anish kapoor 1, eva karapanou 25, kazuo katase 21,

alex katz 5, on kawara 1, emma kay 29, ellsworth kelly 19, roger kelly 26, martin kersels 23, clay ketter 19, aisha khalid 3,

ian kiaer 9, anselm kiefer 11, karen kilimnik 13, scott king 22, peter klare 25, karen knorr 30, unna knox 25,

takehito koganezawa 31, willem de kooning 5, jeff koons 11, igor & svetlana kopystiansky 1, david korty 12, tania kovats 9, michael krebber 30, udomsak krisanamis 16, elke krystufek 13, guillermo kuitca 5, yayoi kusama 16, jim lambie 12, sean landers 2, abigail lane 16, annika larsson 21, jonathan lasker 5, john latham 1, des lawrence 24, tonico lemos auad 25, zoe leonard 21, andrew lewis 10, sol lewitt 1, maya lin 11, simon ling 2, simon linke 17, graham little 9, hew locke 33, robin lowe 16, colin lowe and roddy thomson 20, rosa loy 6, sarah lucas 12, ken lum 21, dietmar lutz 13, rut blees luxemburg 10, peter lynch 15, rory macbeth & darren phizacklea 26, christina mackie 22, kenny macleod 28, myfanwy macleod 25, elizabeth magill 28, michel majerus 9, antje majewski 9, melanie manchot 24, robert mangold 1, andrew mania 20, andrew mansfield 4, margherita manzelli 2, robert mapplethorpe 9, malerie marder 30, walter de maria 11, eva marisaldi 3, mike marshall 25, jason martin 1, stefan mauck 32, philippe mayaux 10, chad mccail 10, corey mccorkle 8, john mccracken 1, paul mcdevitt 33, barry mcgee 23, wendy mcmurdo 15, janice mcnab 10, jason meadows 3, hellen van meene 12, jonathan meese 23, julie mehretu 19, ingo meller 15, dawn mellor 16, alan michael 6, jason middlebrook 26, beatriz milhazes 8, alain miller 4, harland miller 18, richard misrach 7, jo mitchell 31, tatsuo miyajima 6, tracey moffatt 16, donald moffett 8, jonathan monk 1, alex morrison 26, paul morrison 9, victoria morton 12, dave muller 29, matthias müller 5, vik muniz 7, juan muñoz 1, jp munro 12, muntean/rosenblum 30, john murphy 1, david musgrave 2, hiroko nakao 16, yoshitomo nara 8, max neuhaus 1, avis newman 1, seamus nicholson 21, stefan nikolaev 25, jacques nimki 29, paul noble 30, tim noble & sue webster 23, lucia nogueira 4, matt o'dell 25, magdalene odundo 7, chris ofili 16, shannon oksanen 25, hans op de beeck 33, catherine opie 8, julian opie 1, kristen oppenheim 2, tony oursler 1, laura owens 12, giulio paolini 1, cornelia parker 14, erik parker 23, simon patterson 1, giuseppe penone 14, simon periton 12, grayson perry 10, alessandro pessoli 2, raymond pettibon 12, elizabeth peyton 12, daniel pflumm 13, vanessa jane phaff 10, vong phaophanit 8, gail pickering 26, jaime pitarch 33, lari pittman 2, alex pollard 15, elizabeth price 27, monique prieto 3, richard prince 12, ben pruskin 25, marc quinn 19, imran qureshi 3, tal r 16, fiona rae 5, michael raedecker 29, alessandro raho 9, ben ravenscroft 33, charles ray 2, david rayson 30, carol rhodes 15, guy richards smit 26, sophy rickett 13, john riddy 14, james rielly 5, matthew ritchie 19, danny rolph 33, ugo rondinone 12, adam ross 26, eva rothschild 23, michal rovner 8, thomas ruff 32, karin ruggaber 2, allen ruppersberg 2, ed ruscha 11, anne ryan 2, doris salcedo 19, david salle 11, andrea salvino 3, juliao sármento 1, jenny saville 11, silke schatz 28, julian schnabel 5 & 11, gregor schneider 12, david schnell 24, collier schorr 13, thomas schütte 14, sean scully 5, paul seawright 30, zineb sedira 21, richard serra 11, nigel shafran 18, joel shapiro 6, george shaw 28, jim shaw 13, conrad shawcross 8, cindy sherman 2, yinka shonibare 8, david shrigley 8, josé maría sicilia 7, santiago sierra 1, elisa sighicelli 11, mike silva 28, gary simmonds 17, dj simpson 6, jane simpson 9, ross sinclair 21, dayanita singh 14, daniel sinsel 12, andreas slominski 12, bob & roberta smith 28, bridget smith 14, david smith 11, matthew smith 31, michael smith 33, tony smith 5, glenn sorensen 3, johnny spencer 28, nancy spero 4, frances stark 2, hannah starkey 30, georgina starr 13, wolfgang stehle 25, jemima stehli 1, jennifer steinkamp 2, christopher stevens 15, kerry stewart 8, myra stimson 33, rudolf stingel 8, tim stoner 29, annelies štrba 14, thaddeus strode 21, gerhard stromberg 6, john strutton 26, michael stubbs 6, yoshihiro suda 6, hiroshi sugimoto 7 & 19, mari sunna 29, mark di suvero 11, tomoaki suzuki 3, corin sworn 25, philip taaffe 11, neal tait 19, tomoko takahashi 33, fiona tan 14, sam taylor-wood 19, juergen teller 23, mario testino 5, klaus theijl jakobsen 25, jon thompson 4, thomson & craighead 27, david thorpe 30, wolfgang tillmans 30, mark titchner 20, graeme todd 15, grazia toderi 31, fred tomaselli 19, amikam toren 4, nobuko tsuchiya 4, spencer tunick 33, gavin turk 19, alison turnbull 27, james turrell 7, luc tuymans 19, twentieth century 26, cy twombly 11, keith tyson 4, nicola tyson 12, lee ufan 1, juan uslé 14, adriana varejão 16, markus vater 20, jan vercruysse 1, geerten verheus 31, julie verhoeven 27, jessica voorsanger 28, jeff wall 19, mark wallinger 4, christian ward 18, andy warhol 11, marijke van warmerdam 1, rebecca warren 30, gillian wearing 30, gary webb 29, eva weinmayr 25, richard wentworth 1, franz west 11, martin westwood 29, pae white 2, jean-michel wicker 22, jane wilbraham 33, tj wilcox 12, john wilkins 4, stephen willats 16, jane & louise wilson 1, paul winstanley 30, terry winters 19, john wood & paul harrison 31, simon wood 25, francesca woodman 16, clare woods 23, richard woods 23, richard wright 11, cerith wyn-evans 19, sharon ya'ari 1, raymond yap 21, catherine yass 9, shizuka yokomizo 29, lisa yuskavage 2, andrea zittel 12

first published on the occasion of the exhibition 'the galleries show'

royal academy of arts, london, 14 september – 12 october 2002

exhibition curators norman rosenthal and max wigram

royal academy publications

david breuer

harry burden

carola krueger

fiona mchardy

peter sawbridge

nick tite

design bernhard woß

typeset in ehrhardt mt and ehrhardt expert

production and colour origination dawkinscolour

printing graphicom, italy

editorial note

unless otherwise stated, measurements are given in centimetres, height before width, and, for sculpture, before depth

photographic credits 1 dave morgan; 2.1 courtesy of the artist, 2.4–6 marcus leith; 9.1 andy keate; 10.4 stephen brayne; 10.1&6 lee funnell; 14.1 stephen white; 15.1 caroline shuttle, 15.2&3 michael franke; 19.1–6 stephen white; 21.1 mikhail vylegganin; 25 alex gumbel and dave morgan; 26.1–3, 26.5 andy keate, 26.4 roddy cañas; 29.3 FXP photography; 33.2 nick stewart, 33.3 stephen white, 33.5 zanda olsen, 33.6 peter white

british library cataloguing-in-publication data
a catalogue record for this book is available from the british library

ISBN 1–903973–16–3

distributed outside the united states and canada by thames & hudson ltd, london

distributed in the united states and canada by harry n. abrams, inc, new york